The Artist Meets the Critic

Leila Daw

Artist

and

Robert E. Kohn

Critic

First Edition 2014

Text from correspondence between the authors

Artwork and photos of artwork by Leila Daw

Copyright © 2014 Leila Daw and Robert E. Kohn

All rights reserved

Formatting by Joel M. Kohn

Cover art by Leila Daw and Joel M. Kohn

Cover photo of Leila Daw by Nigel Daw

Cover photo of Robert E. Kohn by Peggy Bigogno

ISBN-13: 978-1492937159

ISBN-10: 1492937150

Foreword

This meeting of artist and critic began with an email from Leila Daw in New Haven, Connecticut to Robert E. Kohn in St. Louis, Missouri:

> Hi Bob 10/3/13
>
> I hope you can see my show at the Atrium Gallery—I'd really like to know what you think. There are actually 12 pieces of my work in the two rooms and outside hallway. The 6 of them in the big middle room are new.
>
> Your recent book on your brother's painting sounds great! You do know that Atrium Gallery has moved, around the corner from where it used to be; still just east of Euclid Avenue but now at 4514 Washington Avenue?
>
> Best of luck with the book signing!
>
> Leila

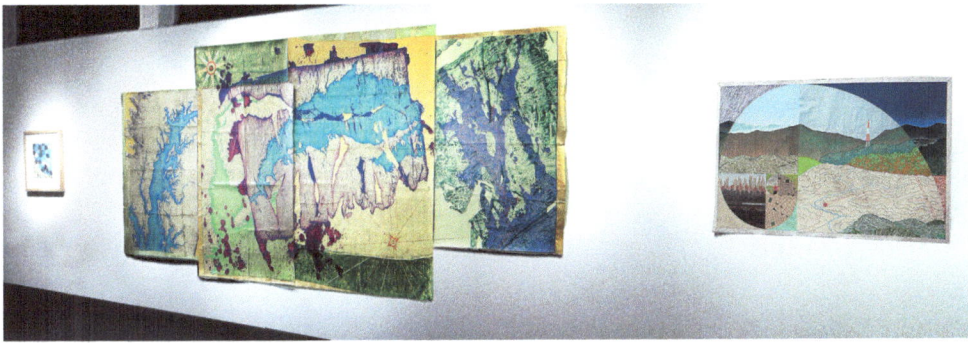

Figure 1. Leila Daw's artwork installed at Atrium Gallery

That same day, Kohn made his way to the new gallery, studied Daw's paintings and took notes. Carolyn Miles, who owns the Atrium, gave him valuable background information based on her 27 years representing Daw. That evening Kohn emailed his thoughts on Daw's paintings to her, and a day later received her response:

> Dear Bob 10/4/13
> Thanks so much for your insightful comments -- and for going to the show! I am responding to some of the comments (below), which made me think anew about some of what I'm doing.
> Very best wishes,
> Leila

The Meeting of Minds

Kohn's writings on Daw's paintings are punctuated by her specific responses which are in a boldfaced font.

Dear Leila, 10/3/13
I spent a full hour relating to your precious paintings at the Atrium Gallery. Since I am so focused on my brother's art now I mainly looked for interests you appear to have shared. I believe that you both have representational painting in your genes going back to the beginning of that oeuvre 45,000 years ago. Not surprisingly you both use imagery reaching back to the Paleolithic cave paintings.

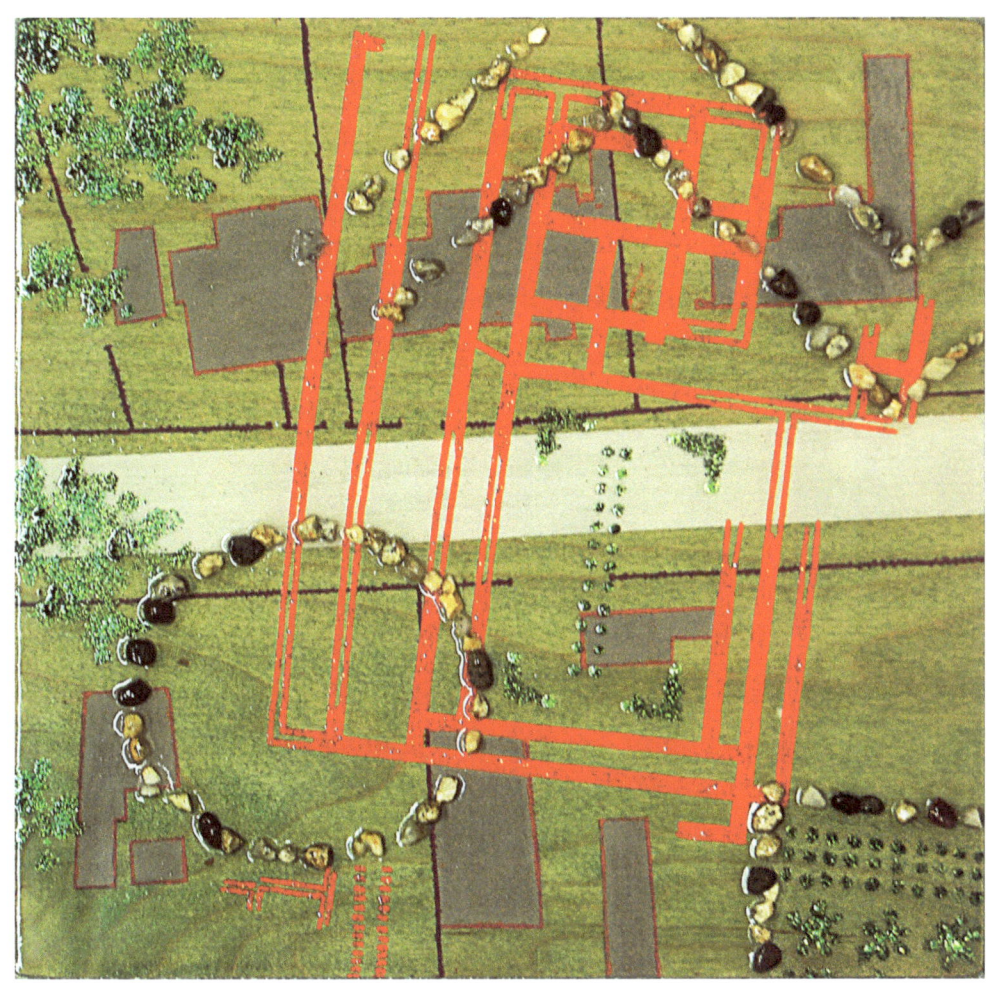

Figure 2. *Persisting in the Land* 2010, mixed media on wood panel, 9" x 9"

In their *Shamans of Prehistory: Trance and Magic in the Painted Caves*, Jean Clottes and David Lewis-Williams refer to the first stage of trance in which
> people "see" geometric forms, such as dots, zigzags, grids, sets of parallel lines, nested curves, and meandering lines. The forms are brightly colored and flicker, pulsate, enlarge, contract, and blend one with another (p.16).

Such dots are prominent in *Persisting in the Land* 2010, as are a wonderful pair of zigzags. There are grids, representing cities in many of your paintings. The topographical contours are your elegant manifestation of the nested curves as well as the meandering lines. Nor is there a lack of parallel lines in your paintings. Your brightly colored forms miraculously flicker! I am really excited about this aspect of your art; I think it's in your genes. Clottes and Lewis-Williams include photographs of some of these geometric forms in their book.

10/4/13

Yes, I think I "see" all these things, in the land, on maps. Or perhaps I project them from my "inner eye" onto what I look at. Whether objectively seen or projected, these forms are in my work. I wonder if this is why I'm so interested in ancient sites and paleolithic and neolithic art?

10/3/13

I see strong allusions in my brother's paintings to the Paleolithic cosmos: "At its simplest, there are three levels: the plane of everyday life, a realm above, and a realm below" (Clottes and Lewis-Williams 29). He picks up the "realm below" in his Grand Canyon paintings (See *A Darwinian Reading of Bill Kohn's Painting*). The deep fissures in *Ballowell Cairn* 2006 are comparable.

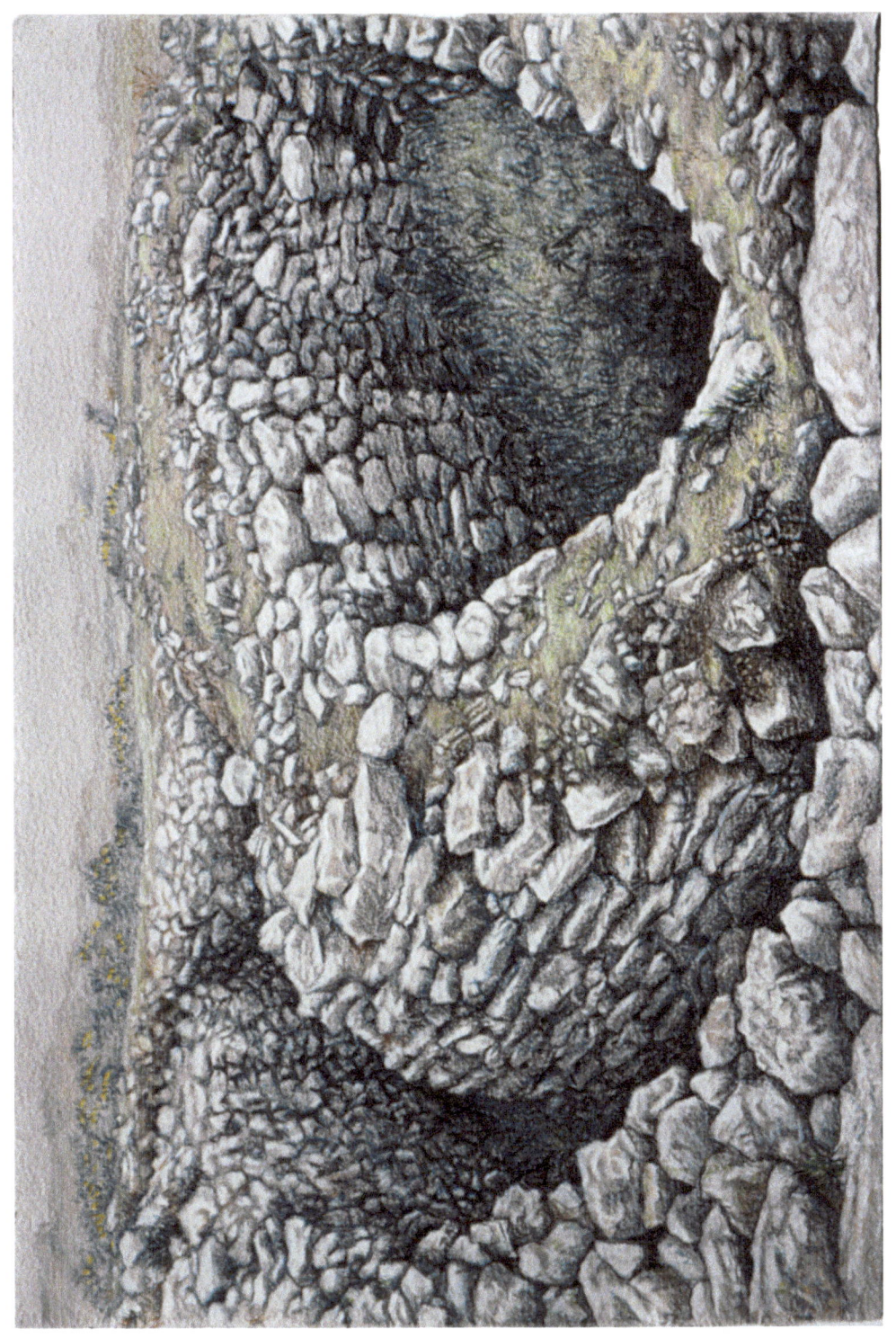

Figure 3. *Ballowell Cairn* 2006, mixed media on paper with welded aluminum and wood, 17 1/2" x 24"

Whereas Bill looks up to the realm above, you Leila look down to it, which is a fascinating difference that I would love to understand someday.

10/4/13

I like to think that I'm looking <u>from</u> the realm above, onto everyday life and the realm below. Does that ring true for you, when you look at my work?

10/3/13

In my other book I detect the anguish that Bill felt, starting his professional career at the same time that Clement Greenberg, with his exhibition *Post Painterly Abstraction* and its introductory essay, attacked the figuration and three-dimensionality on which my brother thrived. You appear to have responded to Greenberg's insistence on two-dimensionality in your *Lanyon Quoit* 2006. The figure is three-dimensional but several large, beautifully patterned areas on the surface of the figure conform to the two-dimensionality of the canvas. Such integration of two and three dimensions in a flat painting, Greenberg would never have thought possible, much less tolerated. It's more interesting to me than anything in Abstract Expressionism. Greenberg insisted that painters "shun thick paint and tactile effects"(3). Ignoring him, you have taken painterly texture to a new high, especially in *Fibonacci Landscape* 2013.

10/4/13

Wow, thank you for this! I do think of incorporating both the two and the three dimensional, and, to a certain extent, a fourth dimension of time, and movement within time, in that I often include reflective materials

The Artist Meets the Critic

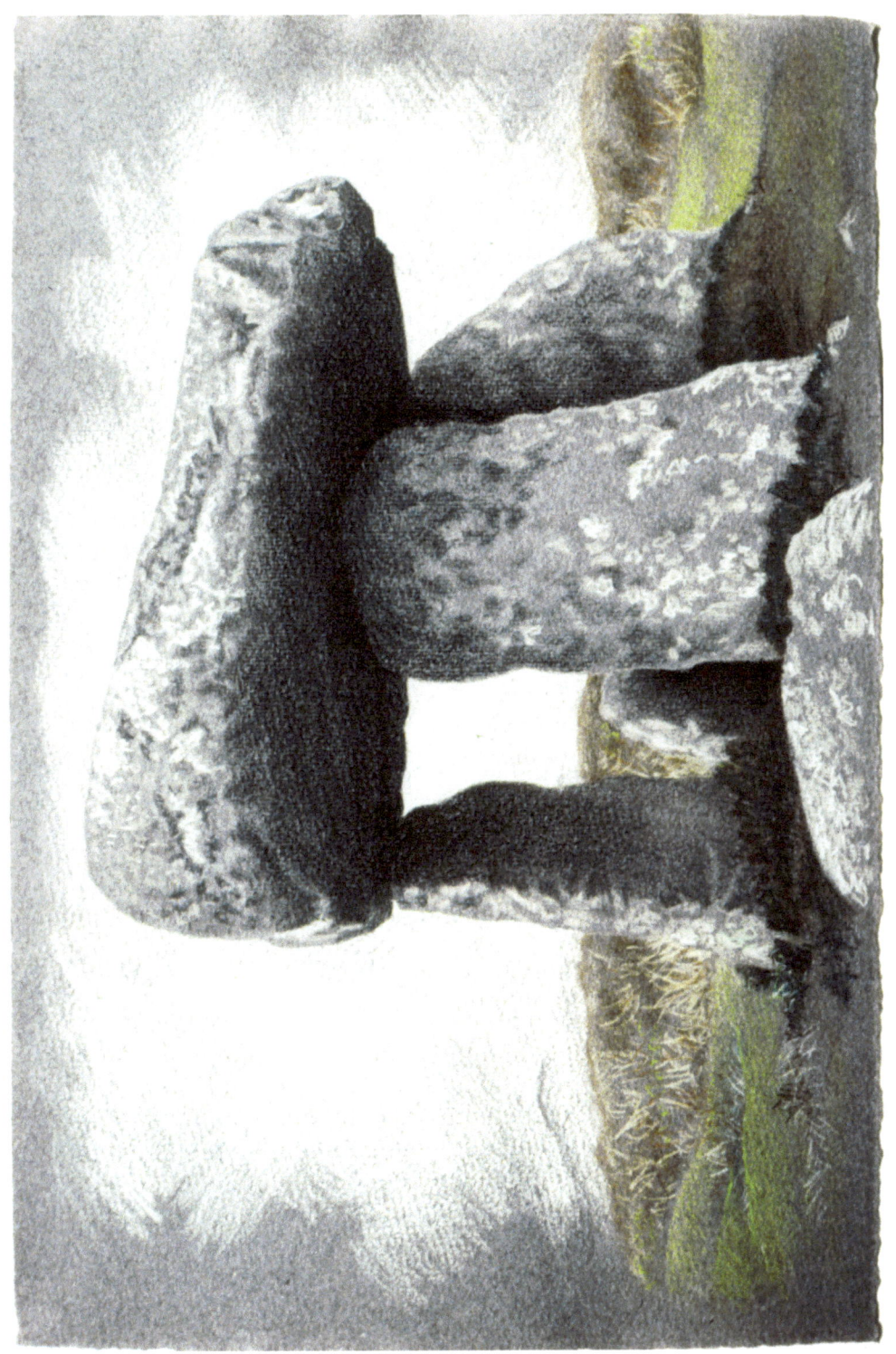

Figure 4. *Lanyon Quoit* 1997, mixed media on paper with welded aluminum and wood, 17 1/2" x 24"

that change as one moves past. Greenberg was interesting to read, but I am not a big fan of him, or of abstract expressionism, which seems self indulgent and without specificity.

10/9/13

Dear Bob

I have been thinking more about "imagery reaching back to the Paleolithic cave paintings" and "the first state of trance" (your words), and I wonder if you could elaborate on whether you find this imagery in these two works from the show at Atrium, *Hill in the City* and *The Ridge*. (These two pieces were in the entrance hallway.) I think it may be there particularly strongly in these two. What do you think?
Looking forward to your analysis!
Leila

10/10/13

Dear Leila,

I think your work reveals a genetic memory of the caves. *The Ridge* is reminiscent of the photograph of the "passage into another world" at the beginning of Chapter 4 of the Clottes and Lewis-Williams book, of the map of the Volp Cave in their Figure 75, and even evokes Figure 77 and its "cracks of a wall of Enlene". I also think that *Hill in the City* associates the Paleolithic Cave with modern culture.

You call attention in the bio to your interest in "the concepts of mapping." The map of the spaces in a cave on page 82 makes me think of your artworks. Clottes and Lewis-Williams suggest that the Paleolithic people saw these spaces as "differentiated by the performance of different rituals" (82). Striking differences show "that different activities were conducted" in "interlinked

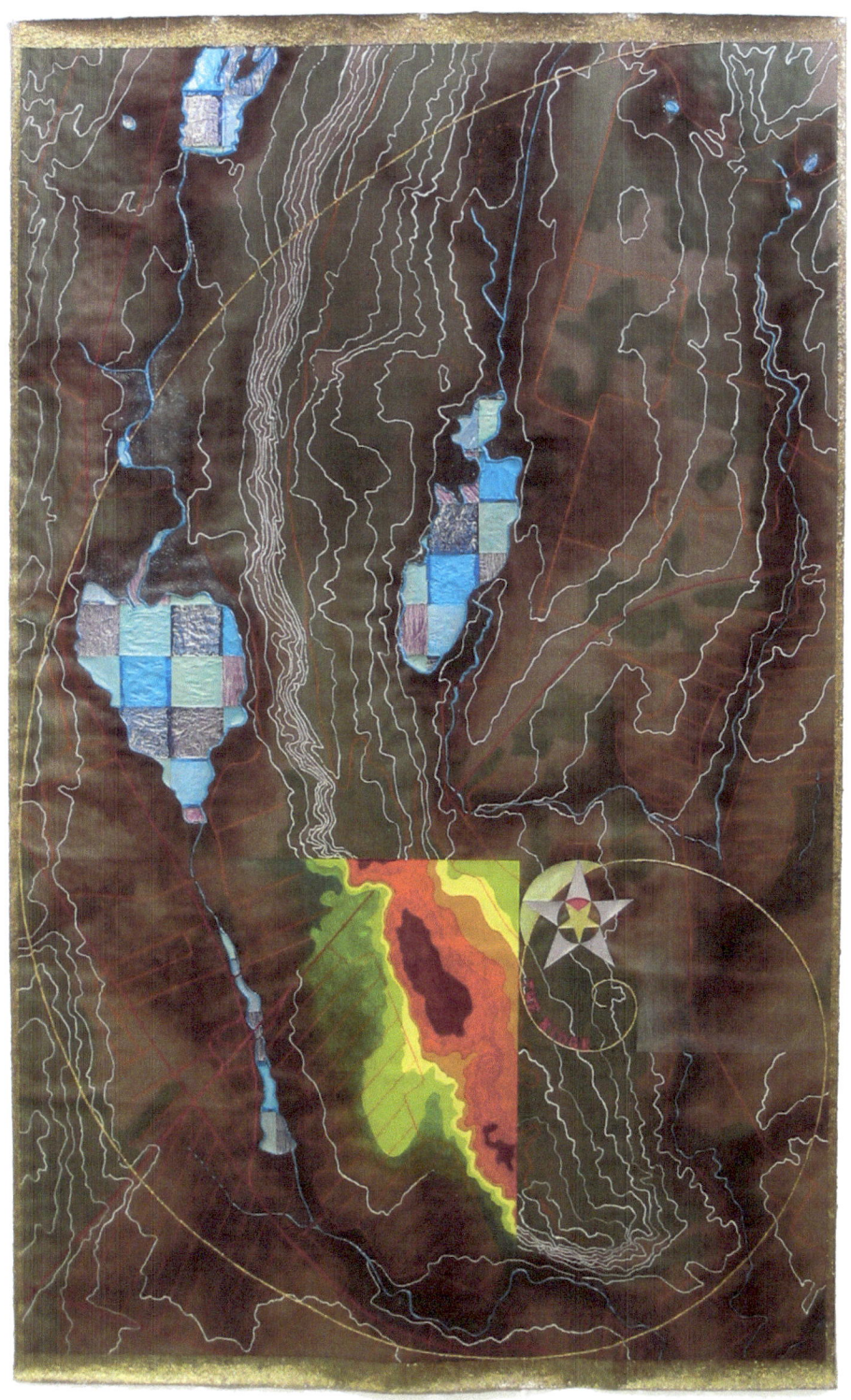

Figure 5. *The Ridge* 2005, mixed media on unstretched canvas, 70" x 42"

caves" (83). In one case, pieces "of bone seem to be associated with small smudges of red paint that were certainly deliberately made but are not images in the strict sense of the word" (83). Later they remark that "people were simply touching—and leaving evidence for their actions on—the walls" (85). "The walls. ceilings, and floors of the caves were therefore little more than membranes between themselves and the creatures and happenings of the underworld" (85-86).

If you find the book by Clottes and Lewis-Williams in your library, you can quickly read THEIR theory relating the zig-zags, concentric circles, etc. to the cave people's going into trances in the caves (This theory was their most famous contribution, I think) I spent months trying to understand early representational art-making for my book on Bill, and I corresponded with Clottes. It was my conclusion that the shaman used and misused the artist. For Bill, Greenberg was just another shaman, to be distrusted. In this view I am most influenced by William Goldings' *The Inheritors*. Is it possible that you read that too? The shaman was a master of hallucination. I don't believe that the best of those cave paintings were done by people in trances.
Bob

10/10/13
Dear Bob,
Your references to, and correspondence with, Clottes is fascinating. I'm particularly interested that you express distrust in shamans, which is probably an example of the fact that the artist-as-shaman is a kind of out of favor idea today!
Personally, I'm actually more interested in what YOU have to say, in continuing the discussion between us, than a (albeit very respected) historian of prehistoric art. I do have a fascination with prehistoric art

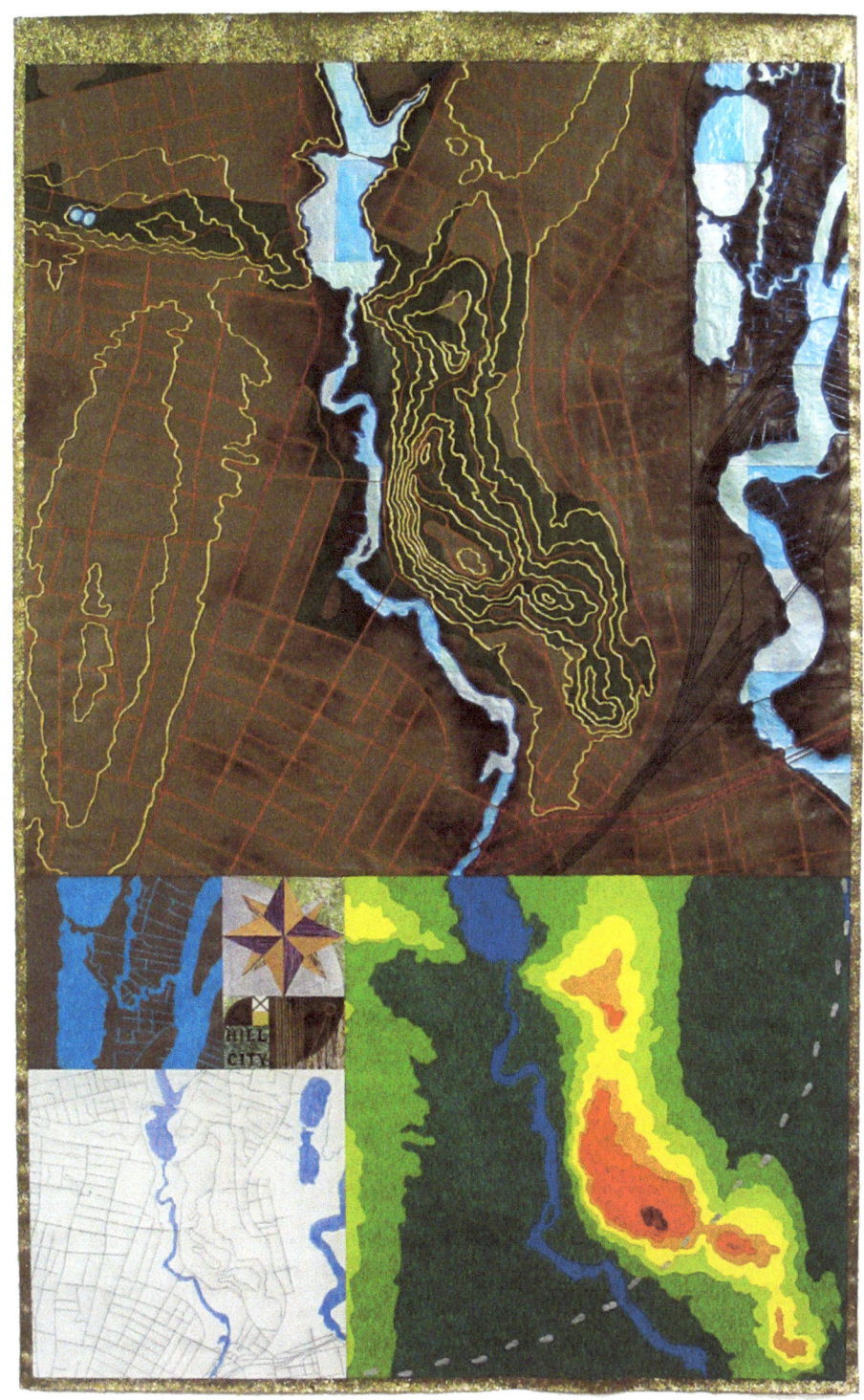

Figure 6. *Hill in the City* 2005, mixed media on unstretched canvas, 70" x 42"

and prehistoric sites, and yes, I actually made a trip to France to see the cave paintings in the Dordogne: in Les Combarelles, Fonte-de-Gaume, Les Trois Freres, and a couple of others, (I didn't go to the Lascaux reproduction) and also Pech-Merle further south in France. And of course there are my drawings of prehistoric sites in Cornwall and Ireland, three of which are in the Atrium show (I even wrote a grant to go over and do those drawings!). So of course I care about how these things look, and even more I'm interested in how it feels to be there. But what is REALLY fascinating is your idea of "art-enabling genes (that) carry the memory of those geometric forms..." I would love to have you talk/write more about that!
Best wishes,
Leila

10/10/13
I'd love to see a picture of your artwork in our Metro. As I recall the setting is cave-like.

10/10/13
Thanks Bob,
My art in Metrolink is in the architectural design for the shape of the tunnels, the bridge piers, and the handrails and foot bridges. There are no images like my mixed media paintings.
Actually I am familiar with Clottes' 2010 book Cave Art, and I think I did read the 1998 book on The Shamans of Prehistory: Trance and Magic in the Painted Caves, or at least I looked at it in the Mass Art library. This would have been in the 90's so I've forgotten a lot of it. You bring up some interesting points from this book, and refresh my memory and make me see Clottes' ideas in new ways.

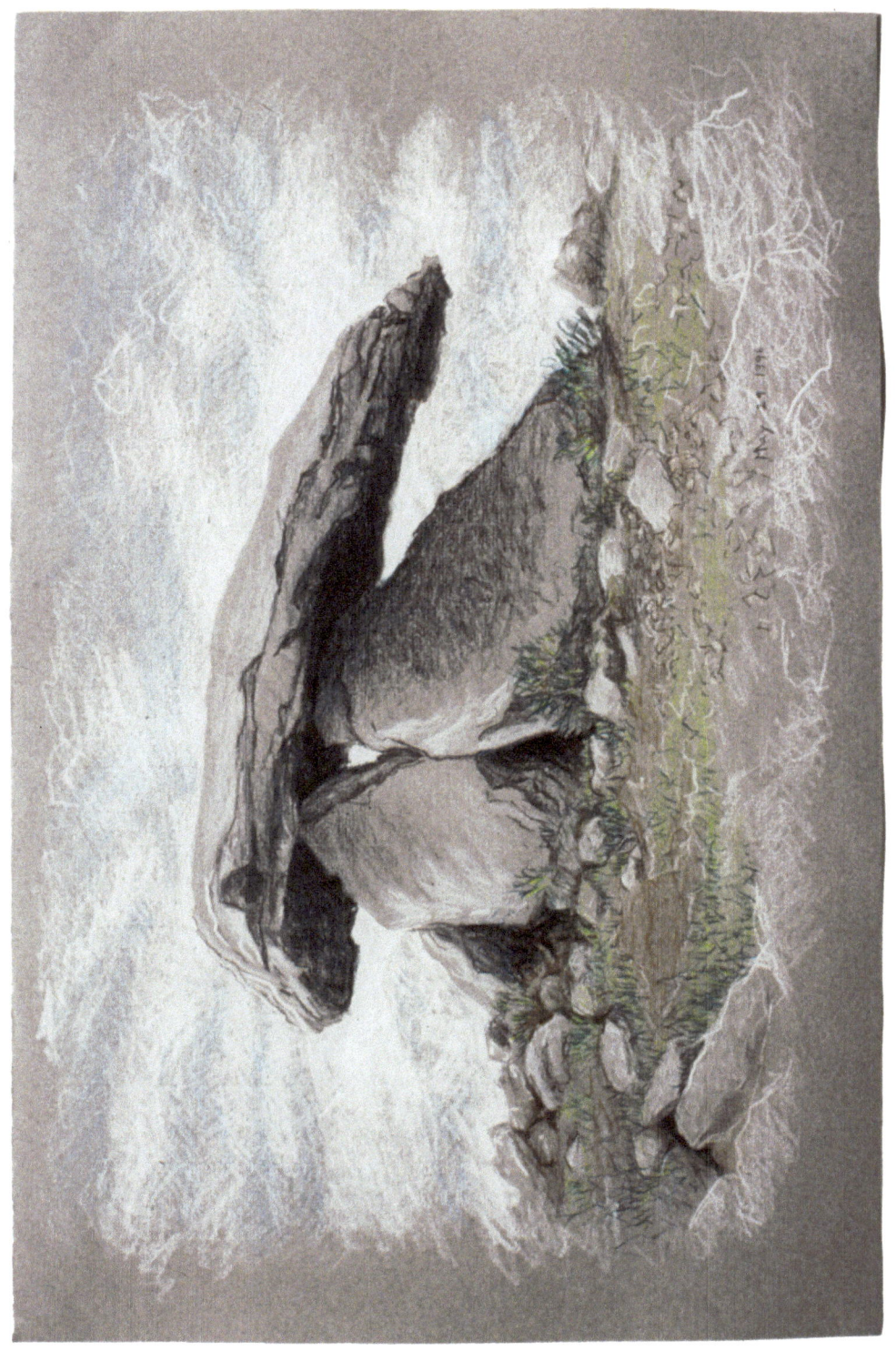

Figure 7. *Chun Quoit* 1996, mixed media on paper with welded aluminum and wood, 17 1/2" x 24"

At Mass Art I taught a course (of my own devising), "Myth and Ritual," and in order to teach it I did a great deal of reading. It was an "every-media" studio course -- students worked on projects from paintings to videos to performances to ritual objects, and we discussed extensively topics like: the artist as shaman, the nature of ritual in art-making, and how personal myth-making influences art-making. The focus was, of course, on <u>contemporary</u> art-making, although prehistoric art did come up.

The artist as shaman, was, as of course you know, a very trendy topic in the 80's and into the 90's, heavily influenced by Joseph Campbell's and Carl Jung's writing. Any book that established artists as shamans, in the present or in prehistory, was popular. So Clottes was a very popular art historian! And of course Joseph Beuys set himself up as the ultimate shaman-artist, although since his death he has been kind of unmasked as a charlatan. But I think the artist-as-shaman notion has fallen out of fashion today as being maybe a bit pretentious. And of course now there is a bit of backlash to Campbell and Jung. It's kind of a shame that ideas in art are so subject to fashion!

What particularly fascinates me in our interchange is how you are seeing in my work a genetic memory of prehistoric shamanic imagery. Although I am extremely interested in these things (I wouldn't have proposed, and taught "Myth and Ritual" if I weren't!), I didn't know this imagery was embodied in my own work until you pointed it out. I don't think I'm a shaman, but it is true that when I'm really immersed in working in the studio, it can be kind of like a trance state. And in this state all kinds of images happen under my hand as I work. Sometimes I visually project my ideas onto the canvas; other times things just kind of happen, as if I'm not in control. Interesting ideas you have!

Best,

Leila

Figure 8. *Summit Rockfall Glaciers* 2011, mixed media on wood panel, 9" x 9"

10/11/13

How interesting that you know so much about Clottes's book, that you have already distinguished yourself in that area. Maybe your reading reinforced your genetic remembrance. Maybe it explains it. What a great teacher you must have been!

So "the artist-as-shaman is an out of favor idea today" I have re-invented the wheel!

You write "But what is REALLY fascinating is your idea of "art-enabling genes (that) carry the memory of those geometric forms..." I would love to have you talk/ write more about that."

Leila, my fascinating idea was suggested on page 55 of Pynchon's *The Crying of Lot 49* with the words: " … you could not hear or even smell this but it was there, something tidal began to reach feelers in past eyes and eardrums, perhaps to arouse fractions of brain current your most gossamer microelectrode is yet too gross for finding."

Whatever it means, that's where the idea came from. But I now believe it. Why was I so desperate to have children, if it wasn't a memory from past humans?

I'd hate to have our book depend on my proving the existence of "art-enabling genes (that) carry the memory of those geometric forms..."

Bob

10/12/13

Dear Bob,

Well, I actually don't know a lot about Clottes; I read his book a long time ago. I haven't read Golding's, *The Inheritors*, or Pynchon's *The Crying of Lot 49*. Clearly I'm not as well-read as you!

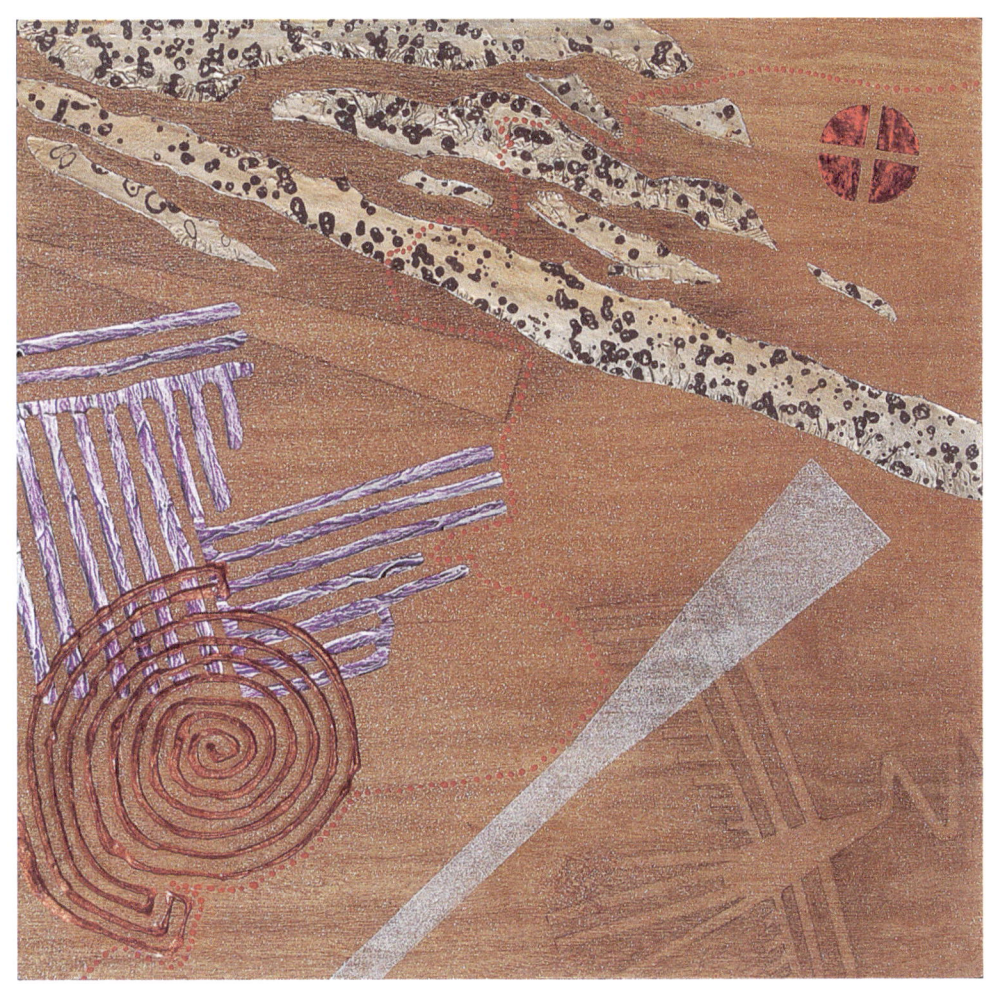

Figure 9. *Forbidden Path* 2009, mixed media on wood panel, 9" x 9"

About shamans: there is actually research that suggests that in some cultures, shamans are real, and helpful to their people. But I don't think there is the necessary cultural structure in our own society for genuine shamans to exist. I prepared a handout about shamans for my Myth and Ritual students, back in the 1990's. I'll have to see if I can dig that up and mail it to you -- but I have no idea where it is right now, and it's not in a format I can send on the internet. I'd like to know your reaction (if I find it!).

You say: "I don't believe that the best of those cave paintings were done by people in trances" which leads me to wonder what you consider the "best." I, like you, do not believe the realistic bison & horses and animals were done by people in out-of-mind trances. But it's possible that some of the repetitive markings might have been done in trance states, don't you think? You say: "I'd hate to have our book depend on my proving the existence of "art-enabling genes (that) carry the memory of those geometric forms..." But I don't think we have to prove the existence of anything. The important thing is to discuss the idea.

I don't know whether we're actually talking about memory or instinct here, and I actually don't think it matters. (I think it was Jean Auel who popularized the use of the word "memories" to describe what some would call "instincts" in her series of fantasy-prehistory books beginning with *The Clan of the Cave Bear*.) I think it's fascinating that you see vestiges of the earliest prehistoric art-makers in the work I'm doing in the 21st century, especially since I am, indeed, fascinated (more than most people!) by the earliest prehistoric art-makers. When I was deep in the bowels of Peche-Merle, I put my hand in the silhouette of one of the handprints next to the famous spotted horses, and my hand fit perfectly! (Yes, today one wouldn't be allowed to do that.)

I'm rambling!

Leila

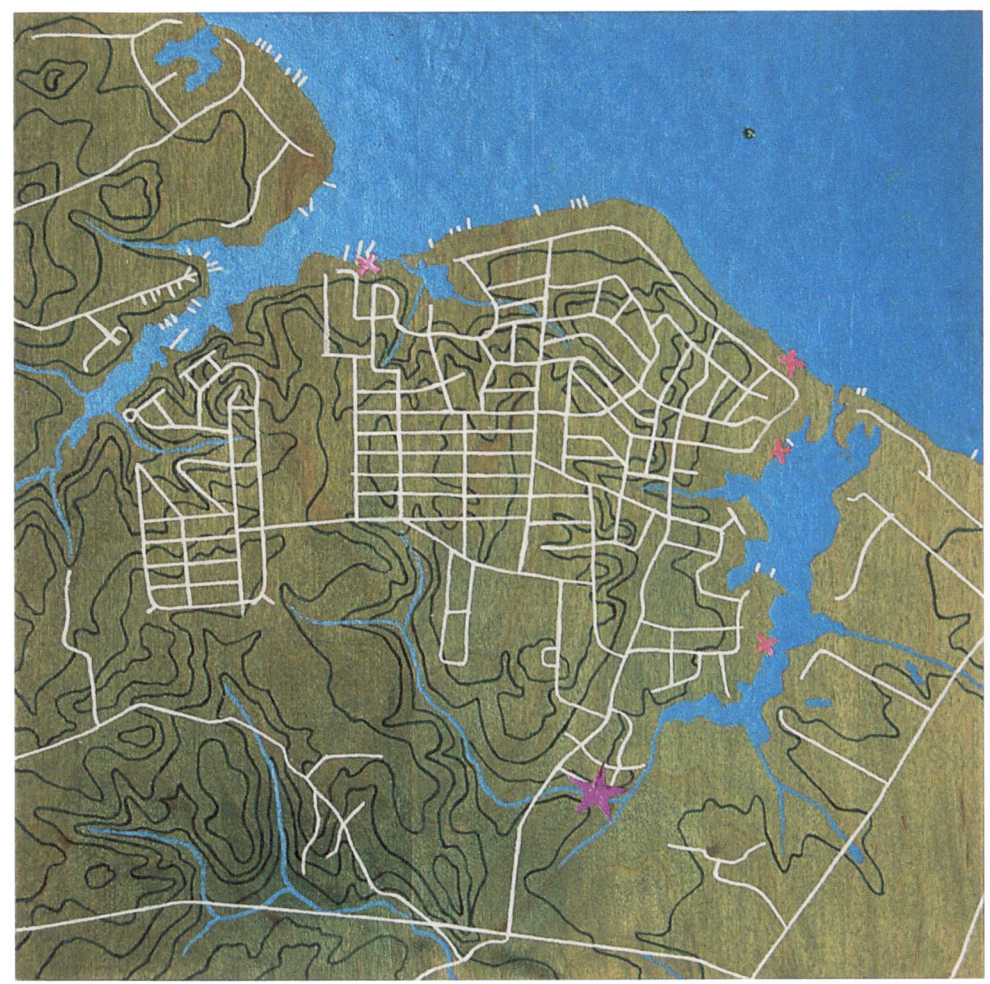

Figure 10. *Destination Cape* 2010, mixed media on wood panel, 9" x 9"

10/12/13

Further question about our discussion:

In both of these paintings you have a grid. In the second it represents city blocks. But what do the grids represent in *THE RIDGE*, and what were you thinking and feeling when you painted them?

Bob

10/13/13

Subject: Re: Further question about our discussion

Well, there are many levels of grids in both these works. The largest, most obvious one isn't just a grid, it's a visual representation of the Fibonacci series, which is in three of the works in the Atrium show. You know the Fibonacci series, right? Each number is the sum of the previous 2, so it goes: 1, 1, 2, 3, 5, 8, 13, 21, 34, etc. You can draw squares with these measurements, going around and around. And, in each square, you can use the side of the square as the radius and the inside point as the center, and draw an arc. The arcs all connect to form a perfect spiral, going out and out. This isn't just some disembodied mathematical thing, it's an organizational principle of nature. You see it in pine cones, and nautilus shells, and other things. I think it's absolutely magic! So, I thought I would use it to organize elements of my landscape-maps, because drawing maps of the land is also an exercise in a kind of almost magic control.

In *Hill in the City*, I'm using it to organize different views of the same map, using different map conventions in each square: topographic lines, elevations as colors, a black and white street map, etc. (By the way, I'm doing something similar in *Fibonacci Landscape*, except there I'm alternating landscape views and map views.) The silver footprints in the lower right square mark out a path along the spiral.

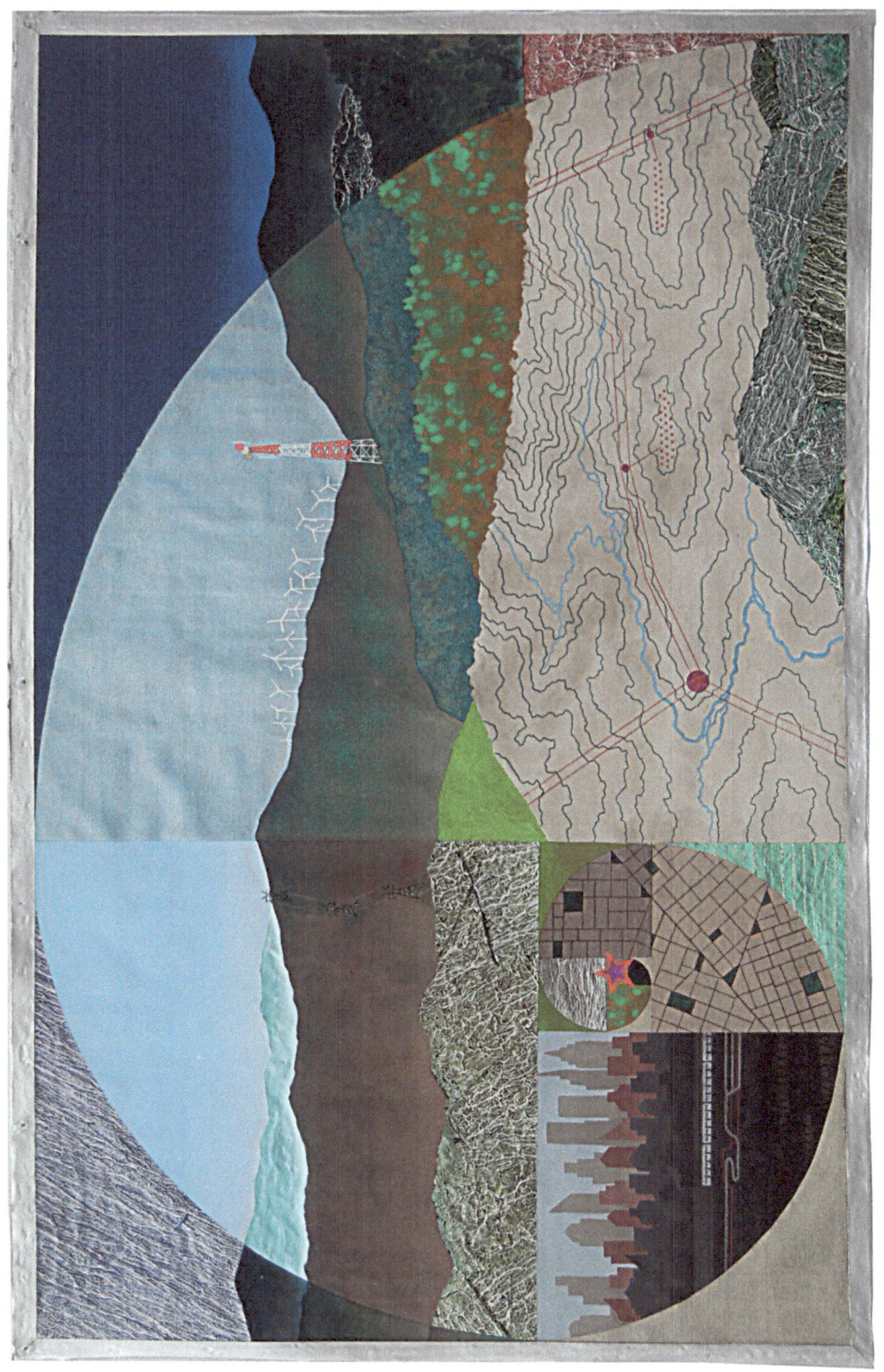

Figure 11. *Fibonacci Landscape* 2013, mixed media on unstretched canvas, 27" x 43"

In *The Ridge*, the demarcation of the Fibonacci squares is more subtle; some of the squares are almost hidden, except for where the elevations-as-colors square overlays the topographic line map. It's all one map, not a series of map views of the same bit of land. But the spiral is more obvious in this painting than in the other; it's a continuous gold line. But there are other grids, too. In both *Hill in the City* and *The Ridge*, there are underlying red and orange grids showing the grid of the streets. (Both these pieces are based on maps of actual places.) People do tend to create grids out of the landscapes in which they live! When I was painting them I was thinking of what they represent -- streets -- and how the pattern of streets conforms to the topography. It was very detailed & rather painstaking work, the kind of repetitive activity that puts me in a meditative state, so part of the time I was kind of in my "zone" and wasn't thinking anything.

So the red and orange grids are not, to my knowledge, coming from my personal prehistoric memories/instincts, because they are strictly representational of something outside myself. But in a sense they do come from something that goes back to the dawn of human beings -- our collective tendency to organize our villages, our communities, our cities, in grid-like patterns. Why do we do this?

Also, the water is gridded off in both works, to reference the way mapmakers like to use grids to section off maps. I think it's peculiar, and counter-intuitive, to grid off the water, which is always flowing and changing and can't really be controlled (as two recent hurricanes in this part of the world have demonstrated!) So I made the water in grids as a kind of perverse act, kind of like King Canute ordering the tide not to come in, as a means of showing his flatterers that he was not as powerful as they supposed.

In a variety of ways in these two pieces, I'm consciously referencing the

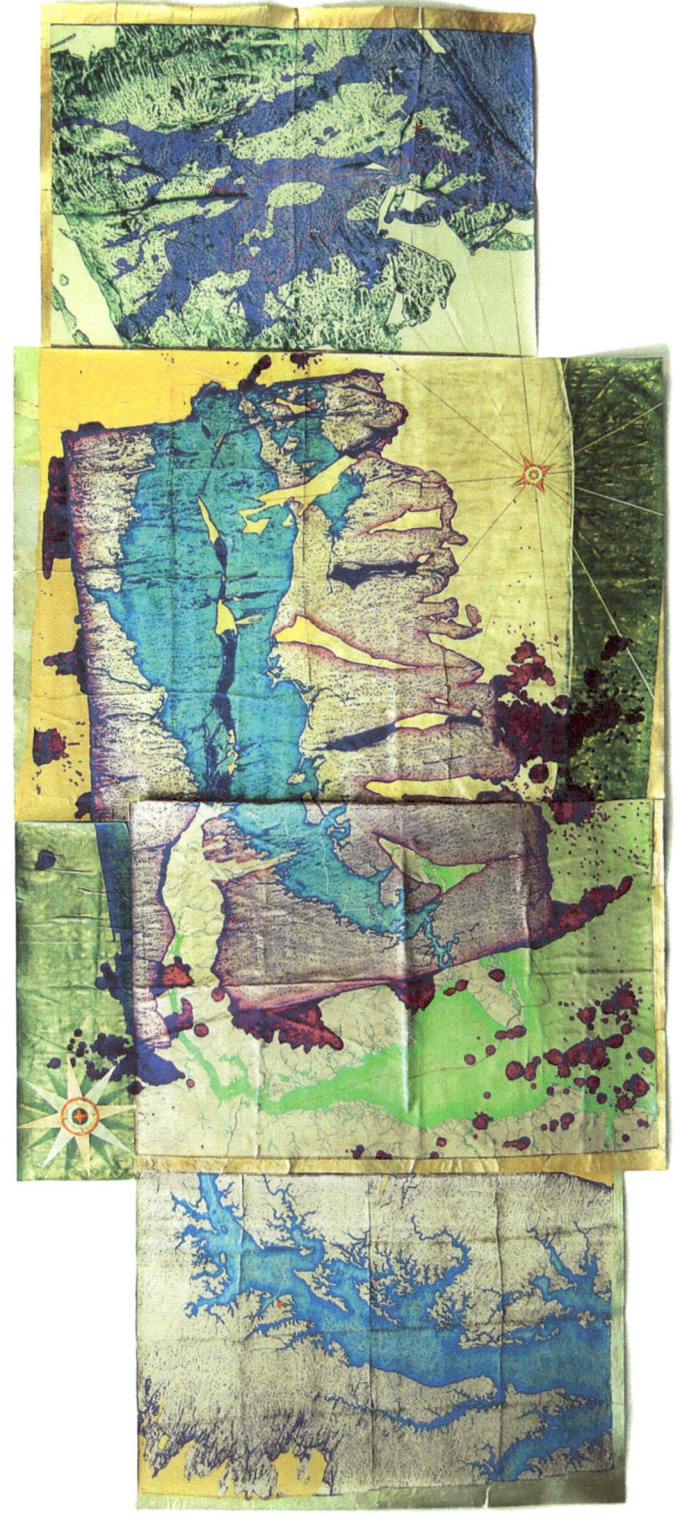

Figure 12. *Northeast Seas Exploration Fragments* 2010, mixed media on silk (canvas backing), 60" x 144"

ways we humans, over the ages, have codified the techniques and conventions for drawing maps. All these conventions have crystallized into what they are today in what seems to me to be a totally arbitrary way, just like my use of the Fibonacci squares and spiral as a means of map organization is totally arbitrary.

10/13/13

I continue to relate this last discourse to Clottes and Lewis-Williams. They write that the cave itself was "clearly meaningful, […] not simply a useful place in which to make pictures." For you, the map spiritualizes the canvas as opposed to the cave. The map itself is made more sacred by nature-predicting mathematics and time-honored inscriptions. It's not the canvas itself that is special; the stars in each of the six-foot paintings declare their manufactured source. You strive to elevate the stature of the painted medium. There is an awe-full lot in your message. I am trying to relate it to Clottes and Lewis-Williams writing that the "effect created by all these images is of human and animal faces looking out of the rock wall, the rest of the bodies being concealed behind the surface of the rock. The figures are not merely painted onto the surfaces; they become part of, and at the same time, interpret the walls of the caves. Most importantly, these images seem to come from behind the walls" (91). Similarly, your "drawing maps of the land is also an exercise in a kind of almost magic control." When you write that "all these conventions have crystallized into what they are today in what seems to be a totally arbitrary way," I think you're saying that they really aren't arbitrary, anymore than the original lines of the Mississippi River at Horseshoe Lake in your documentary piece in my front hall is arbitrary. In all these cases, the magic is the artist's, is it not?

"The Artist Meets the Critic" and the interchange uplifts them both.

Bob

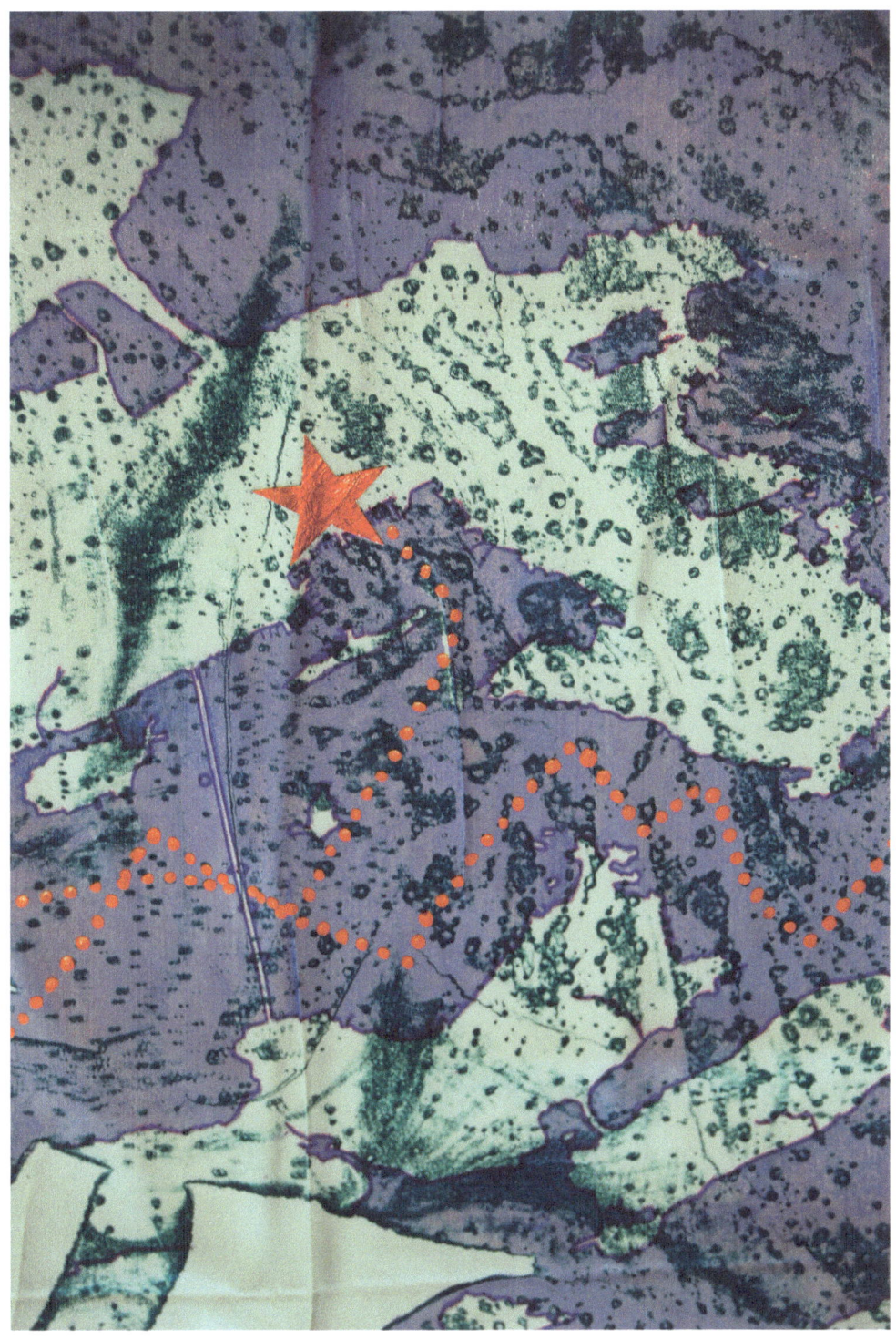

Figure 13. DETAIL: *Northeast Seas Exploration Fragments* 2010, mixed media on silk (canvas backing), 60" x 144"

10/13/13
YES!!

10/13/13

Dear Leila,

I'm dwelling on your Fibonacci icon. I have it too in my prized and only fossil, which I bought at the Tucson Gem Show in 2012. It is an example of ammonite, the Fibonacci fossil. It is thought to have gone extinct 60 million years ago — along with the dinosaurs. Bisected along the middle it reveals the dark brown and the meandering lines in your RIDGE and CITY paintings. I suspect that the Paleolithic people knew these fossils. That takes your imagery back millions of years, not just tens of thousands. This is the only fossil that I own: another connection with your art. I have both halves of this fossil; I would be happy to rush via priority mail one of the halves to you to keep if you'd like. The cover illustration on the Clottes and Lewis-Williams book has intersecting red dots, one of whose branches suggest the beginning of a Fibonacci curve.

10/13/13
Dear Bob,
Wow, what a generous offer --but you need to keep both halves, right and left, don't you?
I don't know if the cover of The Shamans of Prehistory shows the beginning of a Fibonacci curve or not; could it just be a curve following the pathway of the rock? And I don't know whether prehistoric people knew of those fossils. But they certainly knew of pine cones, and of other plants. I found this statement on a website:

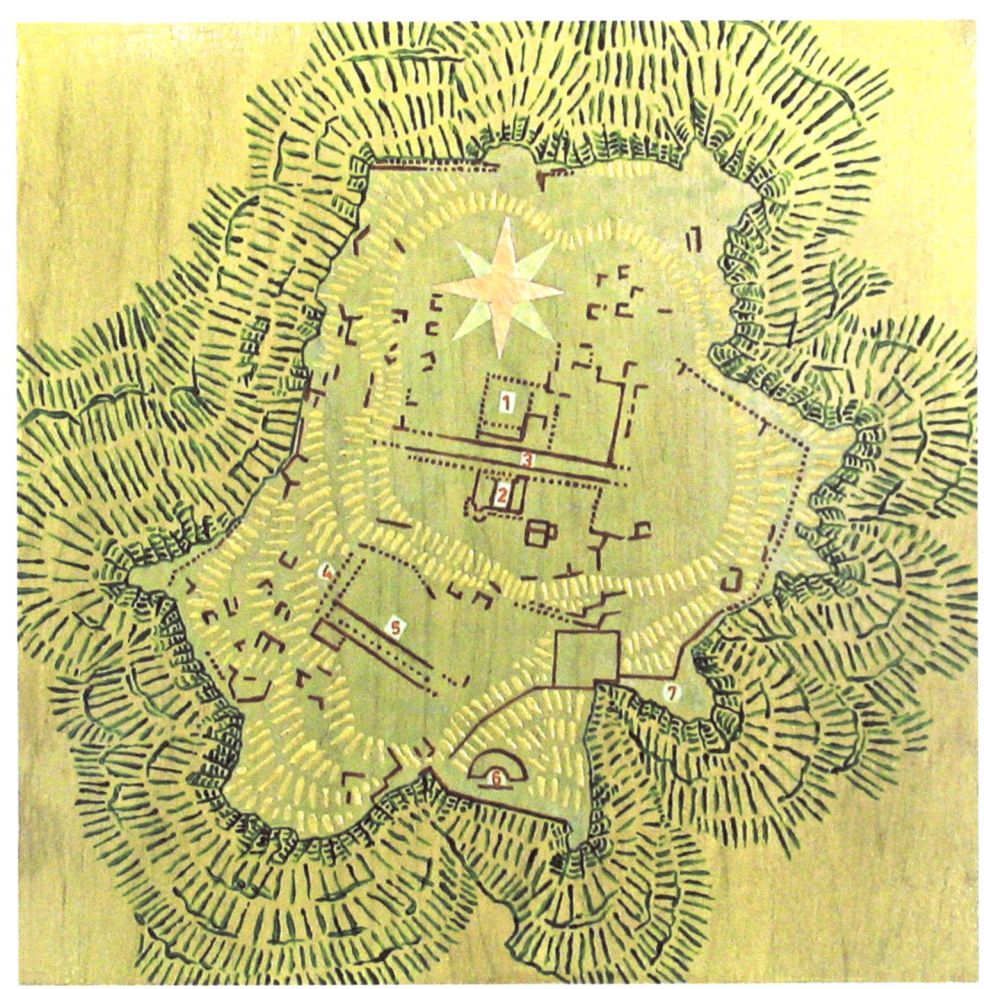

Figure 14. *Lycian City* 2006, mixed media on wood panel, 9" x 9"

Plants illustrate the Fibonacci series in the numbers of leaves, the arrangement of leaves around the stem and in the positioning of leaves, sections and seeds.

I suspect the question is, did they actually figure it out mathematically? I sort of doubt it. I think they likely responded to the magic of it intuitively.

And of course that's what I do.

10/22/13

Dear Bob,

The fascinating (beautiful too!) ammonite fossil was waiting in its box on the porch when I returned last night from taking down my "Rivers" show here in Connecticut. It was nice to return to find and open it, as it's always a bummer taking a show down! I traced the spiral over and over with my finger, trying to figure out if it's a square Fibonacci spiral, or a golden mean rectangle type spiral. Either way, it's magic!

Thank you very much!

Best wishes,

Leila

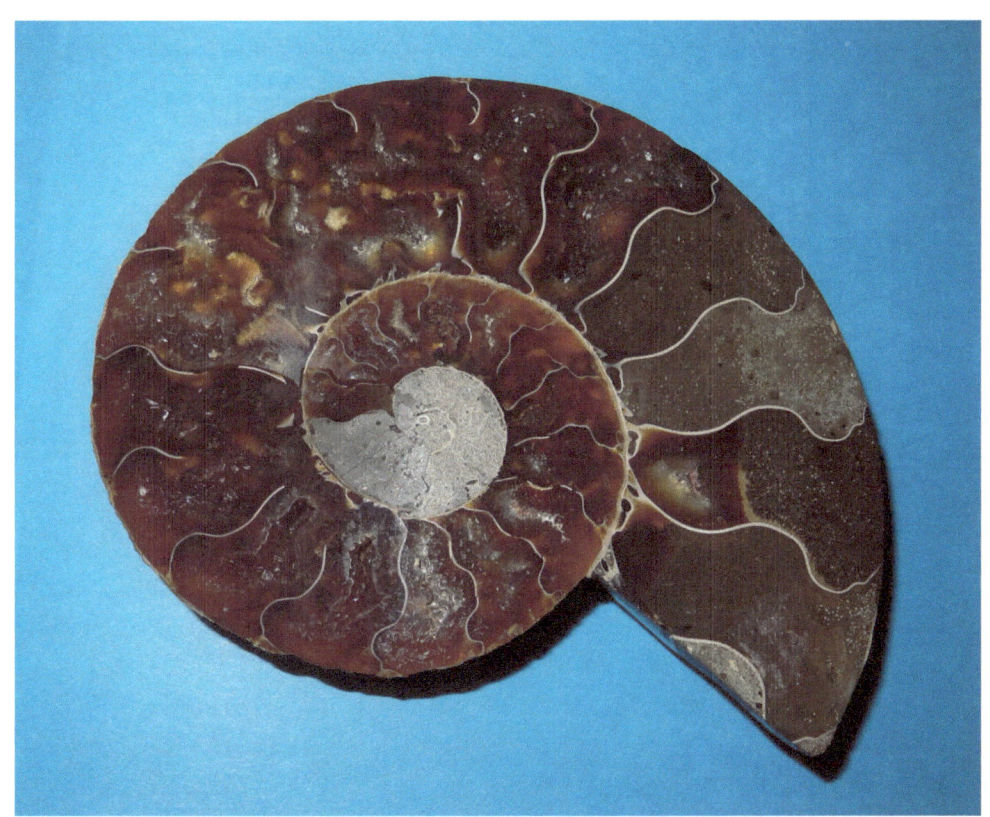

Figure 15. The ammonite fossil

References

Clottes, Jean, and David Lewis-Williams. *The Shamans of Prehistory: Trance and Magic in the Painted Caves*. Translated from the French by Sophie Hawkes. New York: Harry N. Abrams, 1998.

Greenberg, Clement. *Post Painterly Abstraction 1964*.
http://www.sharecom.ca/greenberg/ppaessay.html

Kohn, Robert E. *A Darwinian Reading of Bill Kohn's Painting*. Charleston: Printed by Createspace, 2013.

About the Authors

Leila Daw is an independent artist and Professor Emeritus, Massachusetts College of Art, Boston. Daw's artwork has been featured across the U.S. and Europe, and can be seen as permanent public installations at Bradley International Airport, Hartford, CT; the New Haven Public Library; Northwestern CT Community College, and Metrolink, the St. Louis light rail system. Pieces are in the collections of the Cincinnati Art Museum, DeCordova Museum, Boston Public Library, the St. Louis Art Museum, The Housatonic Art Museum, the Rose Art Museum of Brandeis University, as well as in many corporate collections.

Robert E. Kohn's other publications include journal articles in *Interdisciplinary Literary Studies,* Fall 2008; *Style,* Summer 2009; *Midwest Quarterly,* Winter 2009; *Soundings,* Fall/Winter 2010; and a book on art criticism and theory, *A Darwinian Reading of Bill Kohn's Paintings*. Dr. Kohn is Professor Emeritus, Southern Illinois University Edwardsville.

www.ingramcontent.com/pod-product-compliance
Lightning Source LLC
Chambersburg PA
CBHW050413180526
45159CB00005B/2264